Winnipeg to Lockport, Manitoba, Canada Return Trip Book 9 in Colour Photos, Saving Our History One Photo at a Time

Photography
by Barbara Raué
2016

Series Name:
Cruising Canada

Book 9: Winnipeg, Manitoba Book 9

Cover photo: St. Andrew's Church, Page 6

The Authority on Saving Our History One Photo at a Time in colour photos
Series Name: Cruising Canada

Books 1-9: Winnipeg, Manitoba

Series Name: Cruising Ontario

Books Available in Alphabetical Order:
Aberfoyle, Acton, Alton, Amherstburg, Ancaster, Arthur, Aylmer, Ayr, Belleville, Bloomingdale, Brantford, Brockville, Burlington, Caledon, Caledonia, Cambridge, Clifford, Conestogo, Cornwall, Delhi, Dorchester to Aylmer, Drayton, Drumbo, Dundas, Eden Mills, Elmira, Elora, Erin, Essex, Fergus, Goderich, Guelph, Hagersville, Hamilton, Hanover, Harriston, Hespeler, Jarvis, Kemptville, Kingston, Kingsville, Kitchener, Linwood, Listowel, London, Lucknow, Mariatown to Maitland, Merrickville, Midland, Mono, Morrisburg, Mount Forest, Neustadt, New Hamburg, Newboro, Niagara-on-the-Lake, Oakville, Orangeville, Orillia, Ottawa, Owen Sound, Palmerston, Penetanguishene, Perth, Peterborough, Petrolia, Port Elgin, Portland, Preston, Smiths Falls, Rockwood, Sarnia, Seaforth, Sheffield, Shelburne, Simcoe, Southampton, St. Jacobs, St. Marys, St. Thomas, Stoney Creek, Stratford, Thamesford, Tillsonburg, Waterdown, Waterford, Waterloo, Welland, Wellesley, Westport, Windsor, Wingham, Woodstock

Other Books by Barbara Raue

Coins of Gold

Arrows, Indians and Love

The Life and Times of Barbara
Volume 1: Inventions That Have Enhanced My Life
Volume 2: Entertainment That I Have Enjoyed
Volume 3: East Coast Trips
Volume 4: Olympics Have Always Intrigued Me
Volume 5: Wonders of the World
Volume 6: Caribbean Cruises We Have Enjoyed
Volume 7: Animals
Volume 8: Storms and Other Major Disasters in My Lifetime
Volume 9: Wars, Terrorist Attacks and Major Disasters

The Cromwell Family Book

Laura Secord Discovered

Daddy Where Are You?

Montana Series
Book 1: Montana Dream
Book 2: Life on the Montana Frontier
Book 3: Montana to Boston and Back
Book 4: Montana Sons Go to War
Book 5: Montana Sons Return From War

Visit Barbara's website to view all of her books
http://barbararaue.ca

Table of Contents

Lockport is a small community in Manitoba located twenty-eight kilometers north of the city of Winnipeg. The community is a part of both the Rural Municipalities of St. Andrews (west of the river), and St. Clements (east of the river). Lockport is an ancient settlement, predating European history by thousands of years. It is one of the oldest known settlements in Canada. Flocks of the North American White Pelican are often seen.

The Red River Floodway joins the Red River just north of the dam. The bridge and locks at Lockport (completed in 1910), submerged the St. Andrews Rapids (a natural obstruction to the south) in order to make the Red River navigable through to Lake Winnipeg.

We enjoyed lunch at the Half Moon Restaurant.

South along River Road is St Andrews Church and Rectory. The Church is the oldest operating church in Western Canada. Kennedy House, also located on River Road, was built by Captain William Kennedy in 1866.

Architectural Terms Page 30

Building Styles Page 33

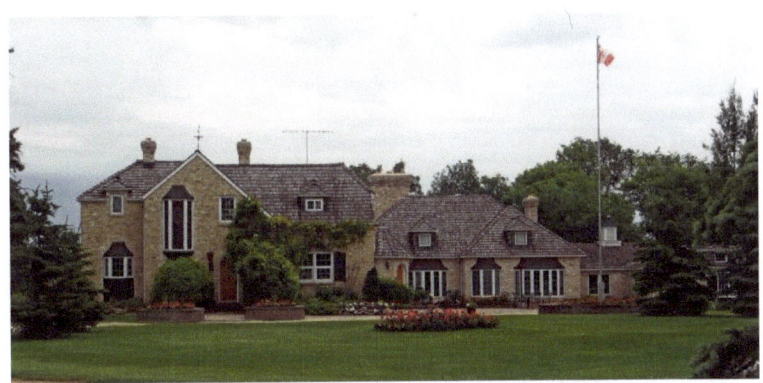

River Road - Tarrow House - This stately English Country Manor is about 4,600 square feet and is situated along the historic Red River; it is surrounded by colorful gardens, majestic trees and manicured lawns. There are oriel and bay windows, and dormers in the attic.

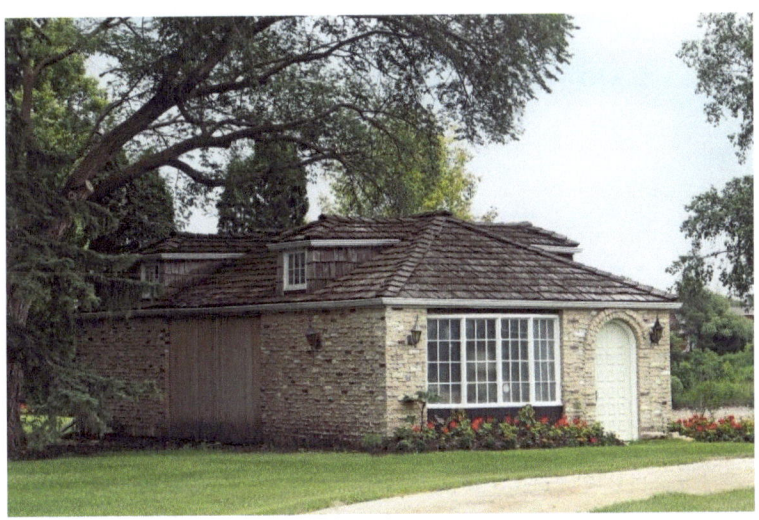

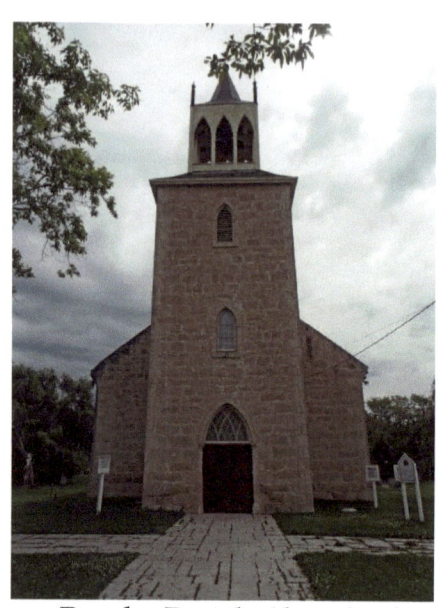

3 St. Andrews Road – Parish Church of St. Andrew – established 1828 – The church was built in 1844-49 in the Gothic Revival style. The walls were constructed from local limestone from the river bank. St. Andrew's Church is the oldest church in continuous use in Western Canada.

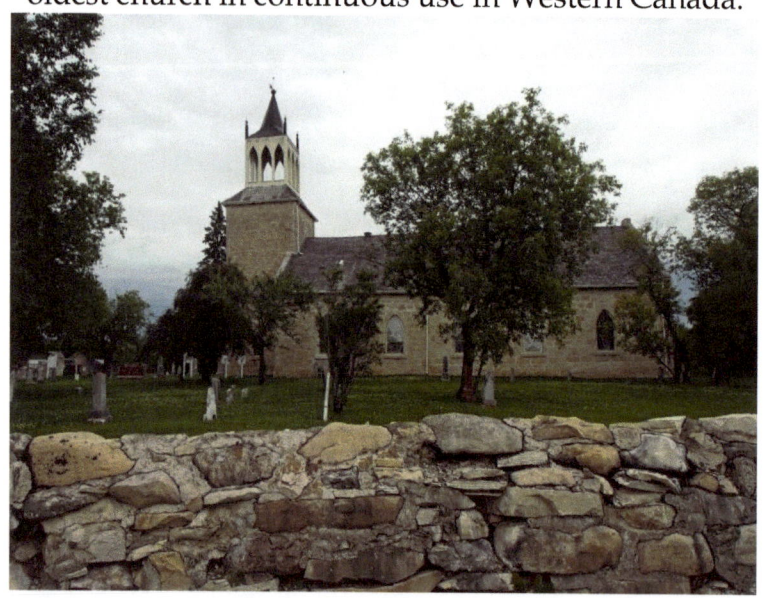

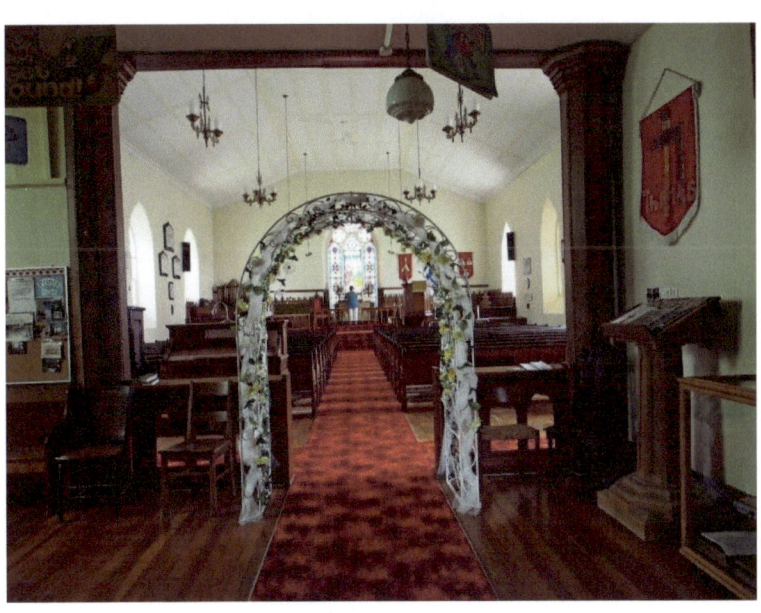

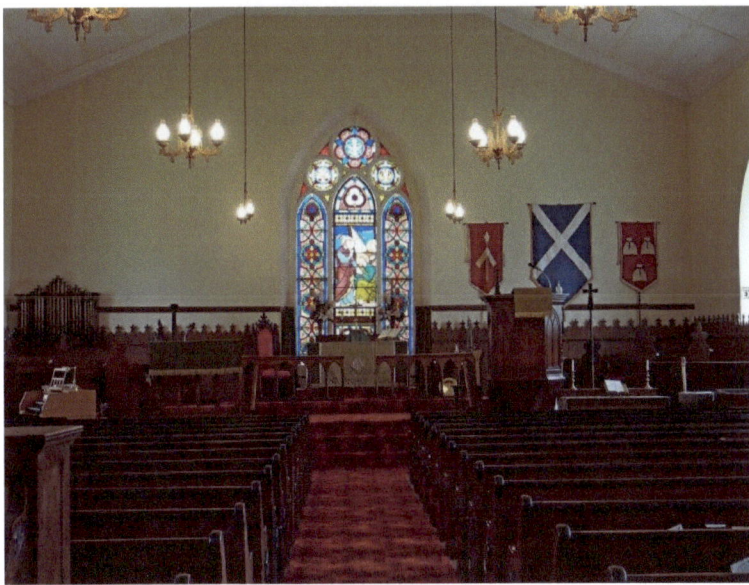

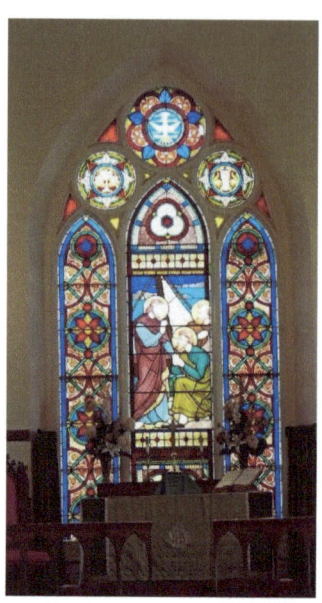

Stained glass window in memory of Archdeacon Cockran was brought from England in about 1890. William Cockran was the first rector of the church.

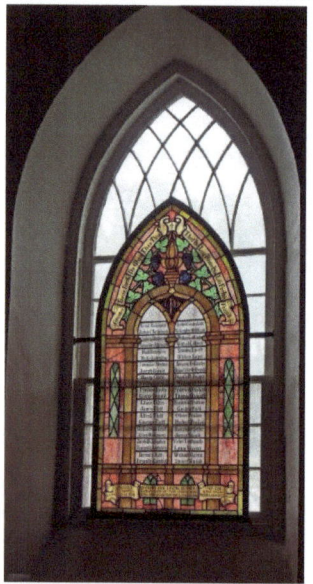

This window was installed about 1920 in memory of Frances Ann Hay, the daughter of 'Alphabetical' Hay who was a government minister at the turn of the Century.

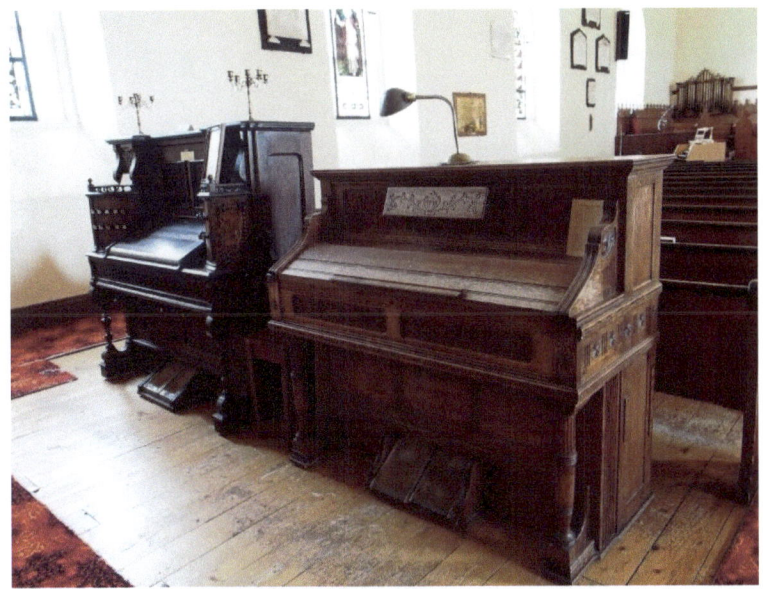

Organs

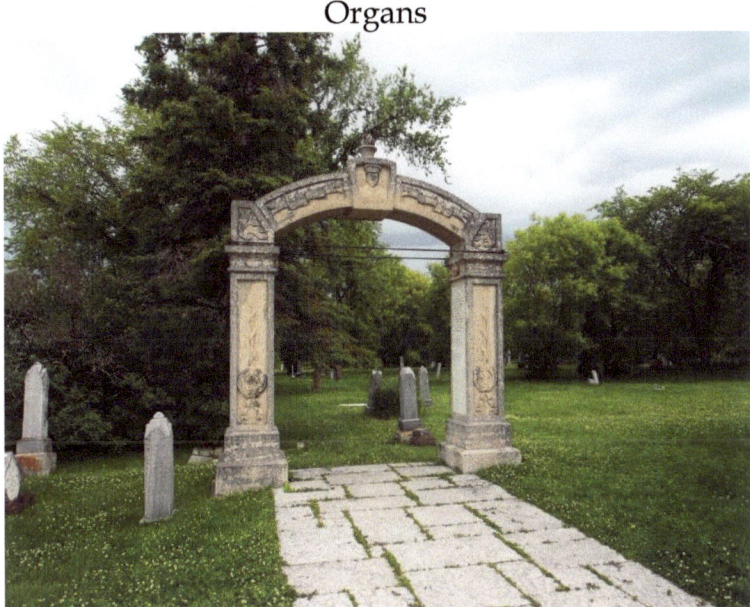

The cemetery tells the story of early life in the Red River Settlement. Typhoid, scarlet fever and diphtheria took a toll on families. The memorial arch is in memory of the men from this parish who fought in World War I, II and Korea.

The church was originally known as "the church at the rapids." With the building of St. Andrew's Dam at Lockport, the rapids have disappeared.

Roar of the Rapids

"Speak up Annie. I can't hear you over the rapids. No we aren't going to the church school. I'd just like to see the construction. They must have to dig a deep trench for the foundation of that new stone church. Cochran is lucky to have so many strong men in his parish used to the hard work of the fur trade. With so many forced to retire from the company they may not have much money to contribute but they have time and muscle. We'd better not dally or he'll be putting me to work.

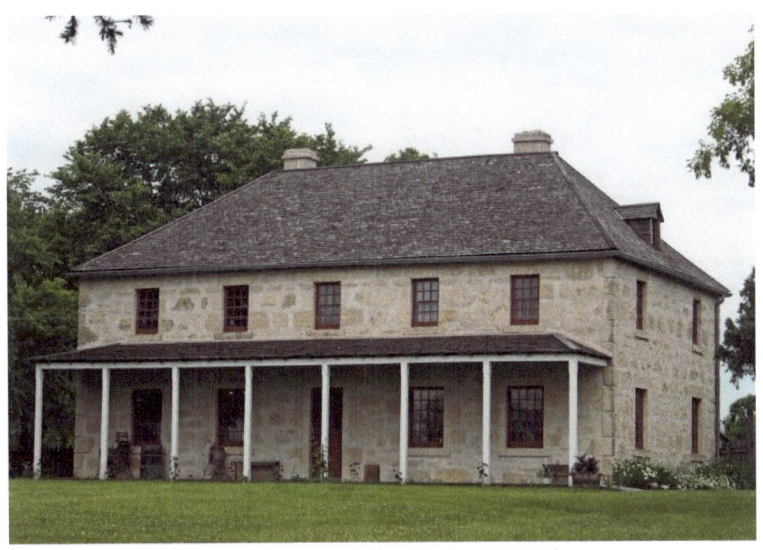

The St. Andrew's Rectory, built in 1854 by stonemason Duncan McRae, is an excellent example of mid-19th century Red River architecture.

Red River

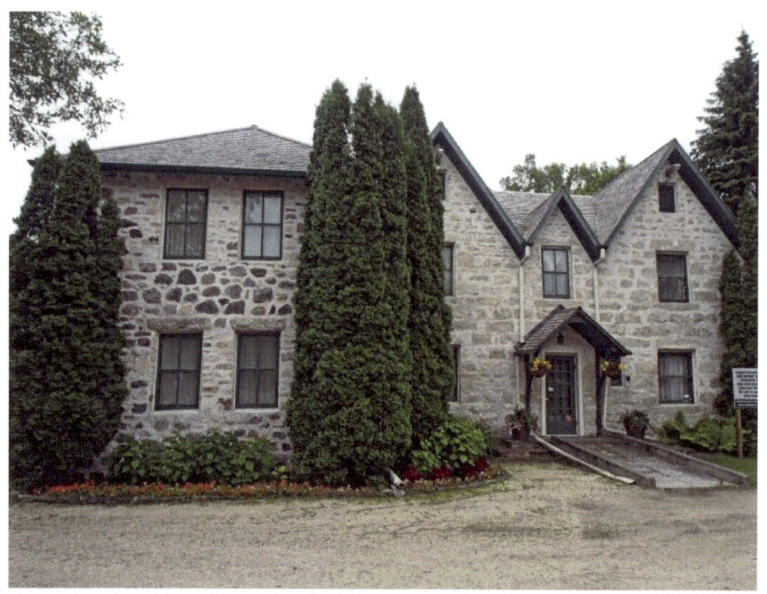

River Road - The Kennedy House – Eleanor called it "Maple Grove" – cobblestone house built in 1866 with large windows, French doors, and modified Gothic gables. Eleanor and William lived here with their children William and Mary. William farmed and kept a trading store on the adjacent north lot.

The Kennedy House, in the Rural Municipality of St. Andrews, was built in 1866 for Captain William Kennedy using stones quarried from the Red River banks at nearby St. Andrews Rapids. The Gothic Revival style of the Kennedy House is architecturally distinctive, compared to the other old stone houses built in the Red River Settlement, which reflect Georgian influences. By contemporary Eastern Canadian or British standards Kennedy House was simple and unadorned. By Red River Settlement standards, however, it was very fashionable.

William Kennedy (1814-1890) was an Arctic explorer, missionary, and a Hudson's Bay Company employee. He was born at Cumberland House on the Saskatchewan River in April 1814, the son of Alexander Kennedy, a Hudson's Bay Company Chief Factor, and an aboriginal woman, Aggathas Margaret (Mary) Bear. When he was thirteen he was sent to Orkney for his education. In 1836 he entered the employ of the Hudson's Bay Company and was stationed on the Ungava Coast. He left the Company's service in 1848 and went to Canada West where he engaged in his own business, and began to lobby for the expansion of Canada into the northwest.

As a lad at Cumberland House he had met Sir John Franklin, and in 1850 he offered his services to Lady Franklin to help in the search for the Franklin expedition. He commanded two of the Franklin search expeditions and discovered the Arctic passage known as Bellot Strait. He was the first to use dogs and sleds from an exploring ship. In 1853, he presented a paper on these adventures to the Royal Geographical Society in London, England, and wrote a book entitled *A Short Narrative of the Second Voyage of The Prince Albert in search of Sir John Franklin.*

In 1856, with George Brown's support, he resumed his efforts to link the Red River Settlement and Canada West by a northern route. About 1860 he settled at Fairford, on Lake Manitoba, as an Anglican missionary and teacher to the Indians. In 1861 he settled at St. Andrew's on the Red, where he was for a time employed by the Hudson's Bay Company as a storekeeper at Lower Fort Garry. He was an early advocate of a railway to Hudson's Bay.

About 1859, he married Eleanor E. Cripps and they had two children.

Crippled by rheumatism for most of his remaining years he lived a very retired life at St. Andrew's. He died at his home on January 25, 1890.

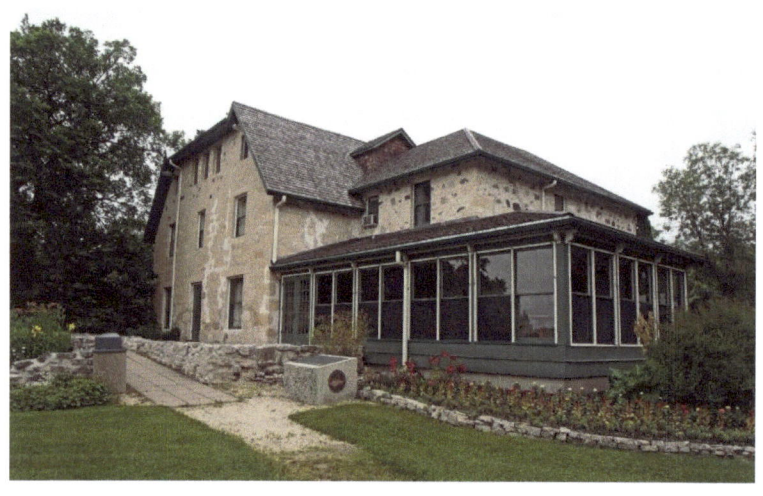

Views from Kennedy House grounds

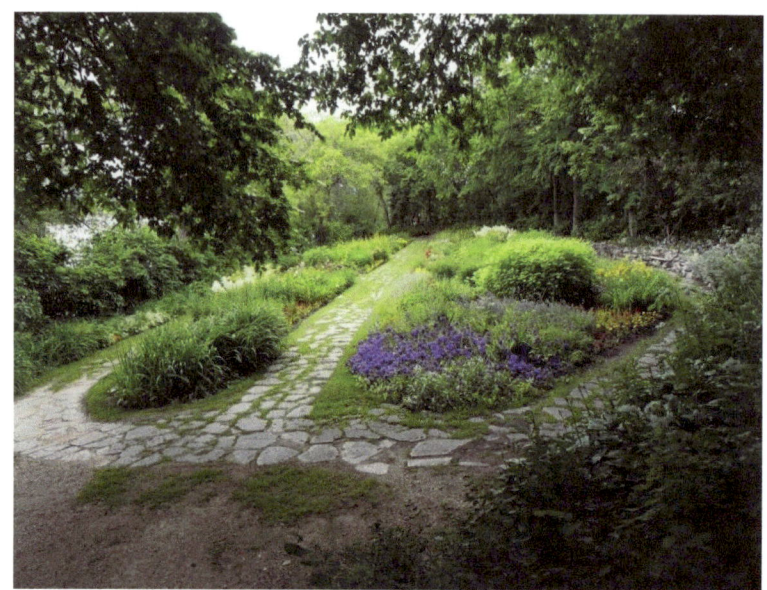

The original flagstone paths and formal flower beds in this garden were part of a traditional English design built in the 1920s by the owners at the time, J.E. McAllister and his wife Caroline.

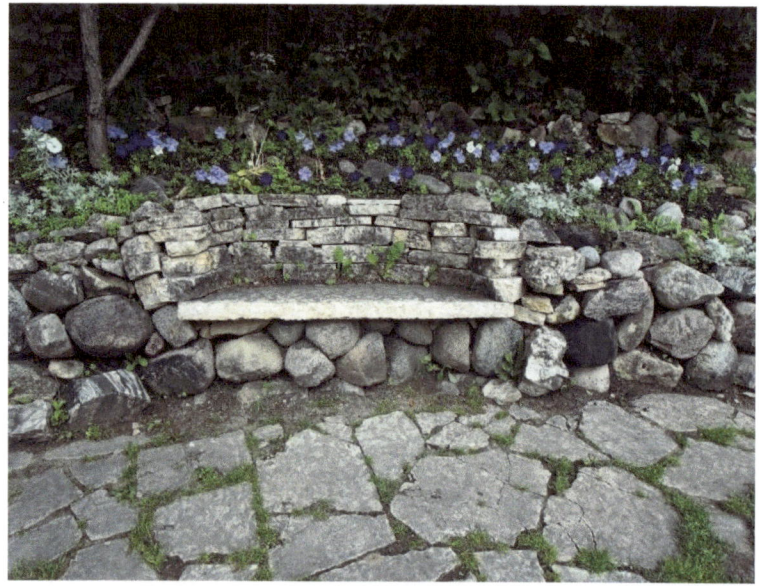

Garden seat

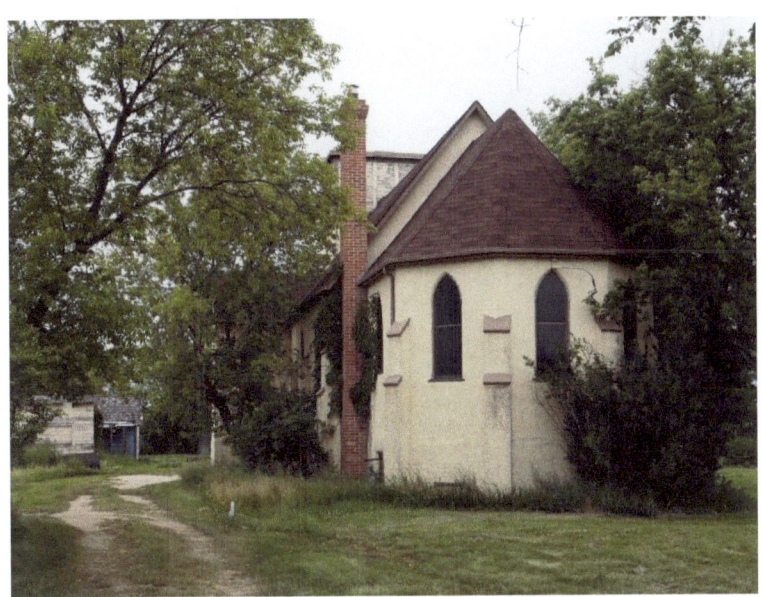

Lancet windows, buttresses

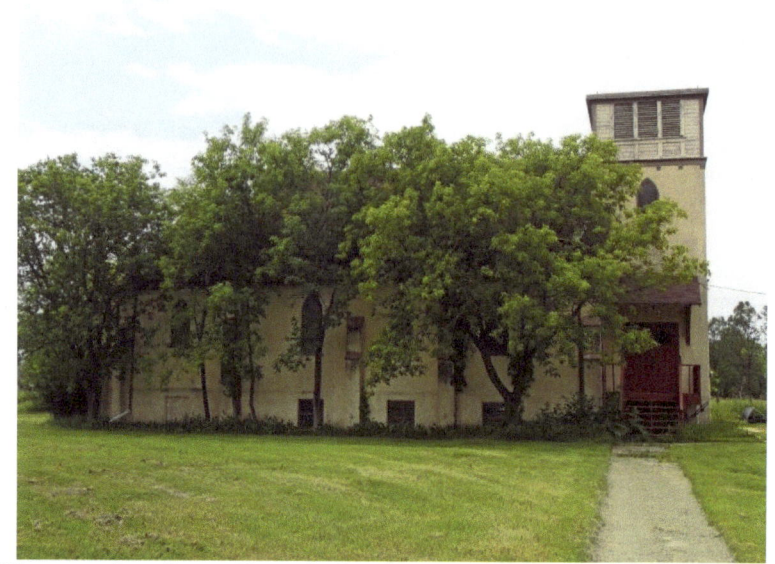

St. Thomas Anglican Church, Lockport (established 1867) was built in 1906 with the chancel being added in 1913 along with a memorial tower. In 1930, the present church was reconstructed and it was dedicated on December 7, 1930. The last service was held at the church on January 15, 2012.

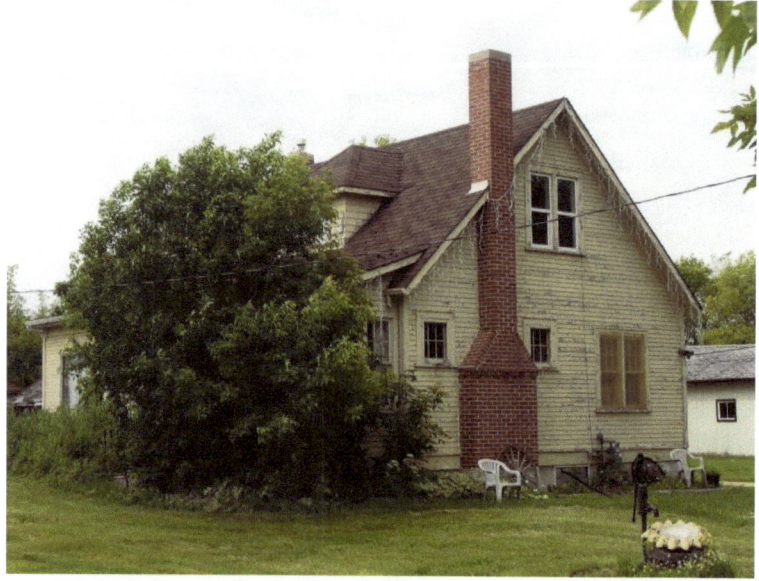

Lockport house – Gothic, dormer in attic

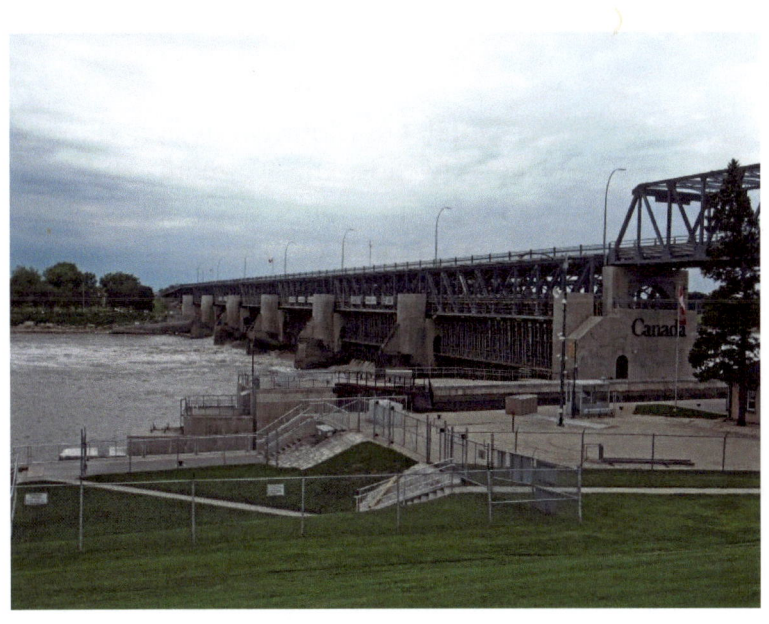

St. Andrews Lock and Dam

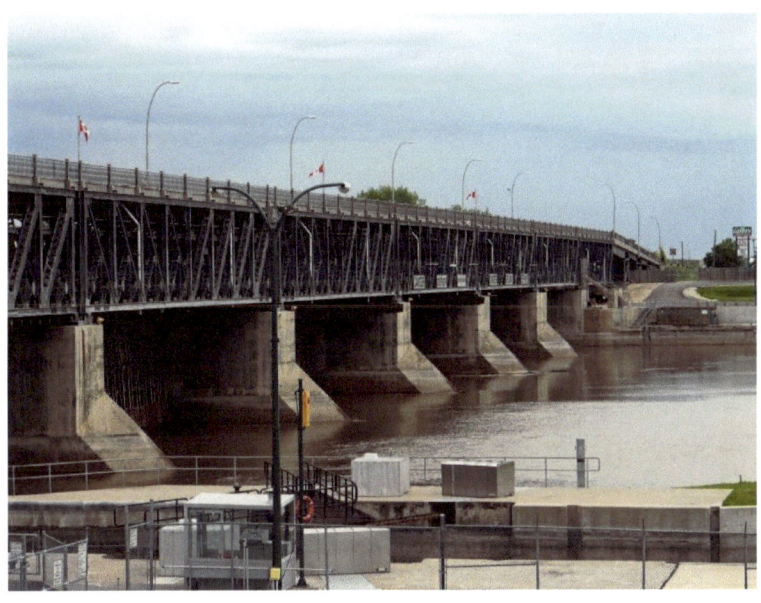

Architect H. E. Vantelet of Montréal designed the St. Andrews Lock and Dam. He chose the "Camere" style found in France and modified it for the unique circumstances of the Red River. Construction began in 1908. The first ship to pass through the locks was the government steamer Victoria on May 2, 1910. The official opening took place on July 14, 1910 when the Winnitoba sailed from Winnipeg with Prime Minister Wilfrid Laurier and his Public Works Minister William Pugsley, the man credited with getting the often-stalled project completed. The lock is the only one on the prairies and measures eleven meters deep, 62 meters long and 13.7 meters wide. Each curtain in the dam is made up of 50 Douglas fir laths, each four meters long and two meters wide.

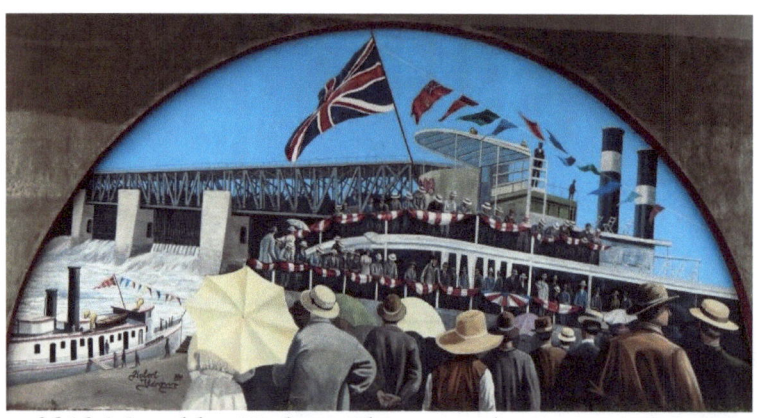

2010 Mural by Hubert Theroux of opening of dam

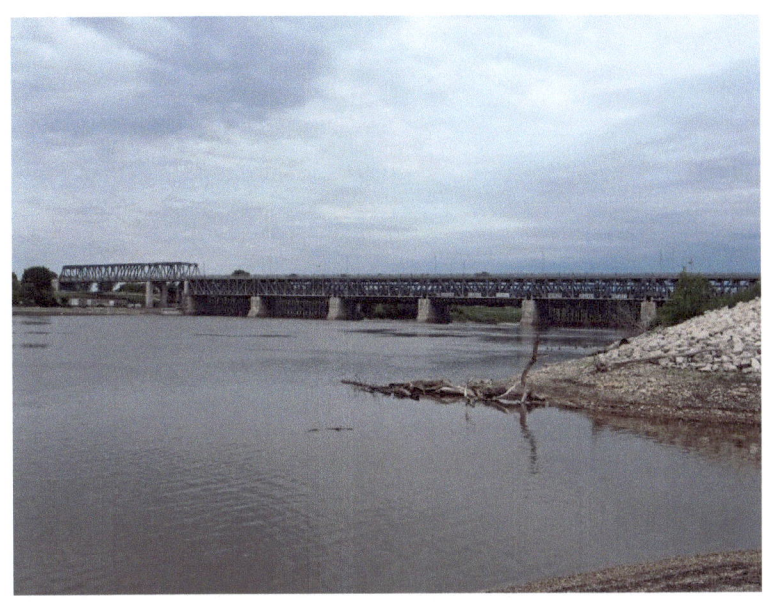

St. Andrews Lock and Dam

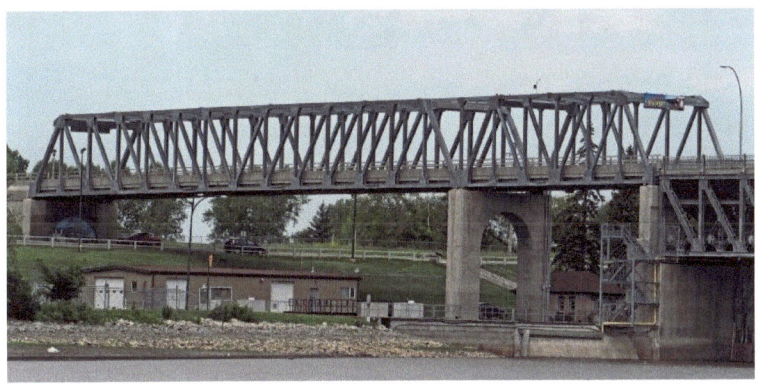

View from dam

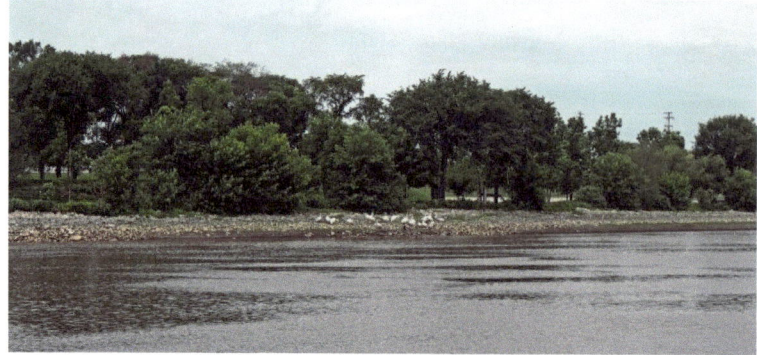
Pelicans across the river

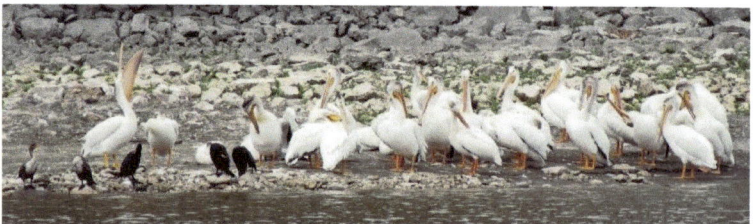
Pelicans

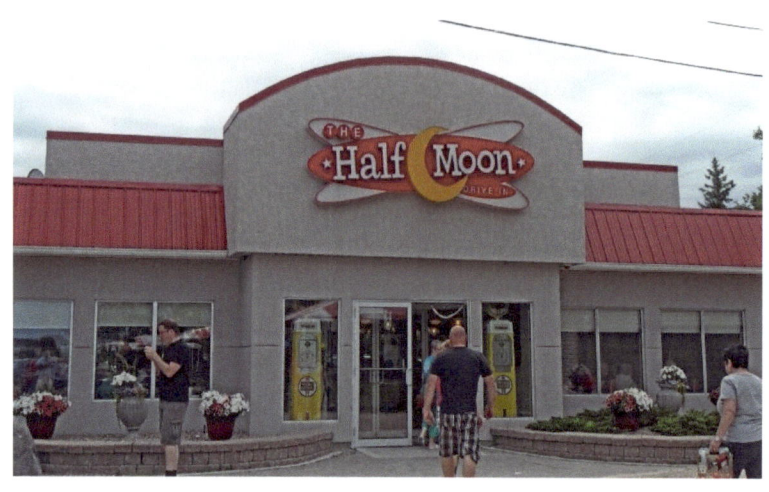

Half Moon Restaurant

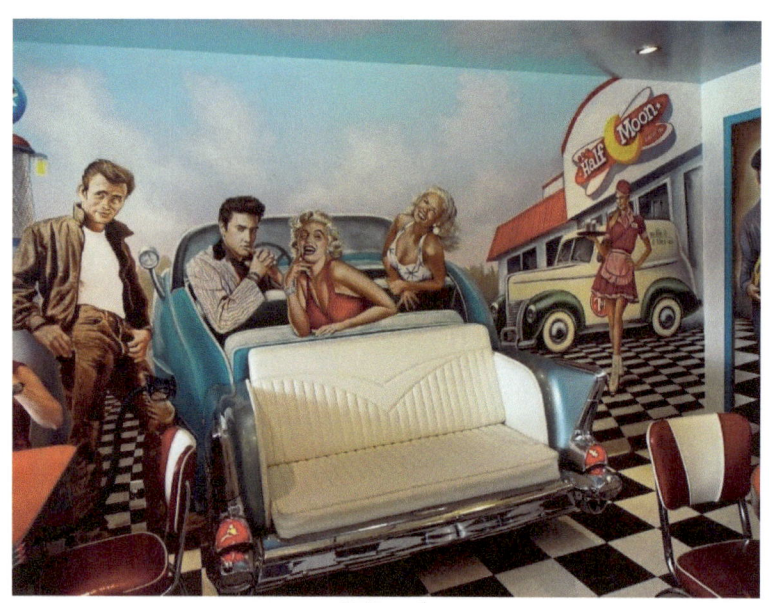

Mural

The Half Moon Drive In

Established 1938

ROCKIN ON THE RED
JULY 15, 16 & 17 - FREE WEEKEND EVENT

Concerts Friday and Saturday Night starting both nights at 6:30pm - 11:30pm

Sunday Family Fun Day at 12:00pm - 5:00pm

Fireworks Friday & Saturday night starting at approx. 11:30pm

Facepainters, magicians, clowns, car shows

Enjoy local and professional mascots on hand all weekend

Free shuttle service provided with overflow parking provided

Please visit our webpage for more info on the event

WWW.HALFMOONDRIVEIN.COM

HOURS OF THE EVENT AS FOLLOWS:
FRIDAY NIGHT (concert night only) 6:30pm - 11:30pm
SATURDAY NIGHT 1:00pm - 11:30pm
SUNDAY 12:00pm - 5:00pm

HALF MOON ON WHEELS

Let the good times roll! The Half Moon Drive-In is going mobile with the launch of our first ever Half Moon food truck, serving up more great food and good times ... hot diggity dog!

Our new mobile unit is a very exciting addition to the restaurant and we'll be dishing out more of our good ol' fashioned food in mobile style. Homemade fresh burgers, fries and of course our famous hot dogs are all on the menu. Featuring a music video sound system, showcasing your favourite bands of the '50s, '60s and '70s, sit back and relax while sipping on a cold pepsi in the hot summer sun.

With its state of the art equipment, this mobile truck will be one of the most efficient to hit the road in Manitoba. Launching the summer of 2014, the Half Moon on Wheels will be hitting the road and will be a regular on the Winnipeg and rural scene. Rolling out on the heels of the Half Moon's 75th Anniversary in 2013 (1938-2013), this mobile truck marks another chapter in the legacy of the Half Moon Drive-In.

For more information on private bookings or parties, concerts and special events, just shoot us an email: halfmoon@mts.net

HALF MOON DRIVE IN - LOCKPORT, MANITOBA
ROCKING ON THE RED
LET THE GOOD TIMES ROLL
JULY 15, 16 & 17, 2016

madison lane boutique

Right Next Door Ladies!

FRESH START

Fashion

75 years of great food — LET THE GOOD TIMES ROLL!

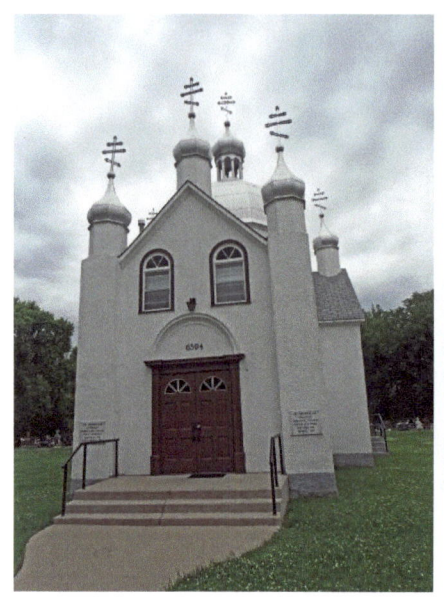 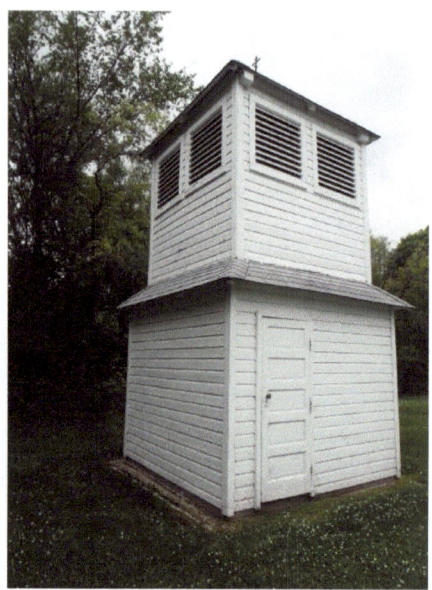

Bell tower
St. Nicholas Ukrainian Orthodox Church at Gonor

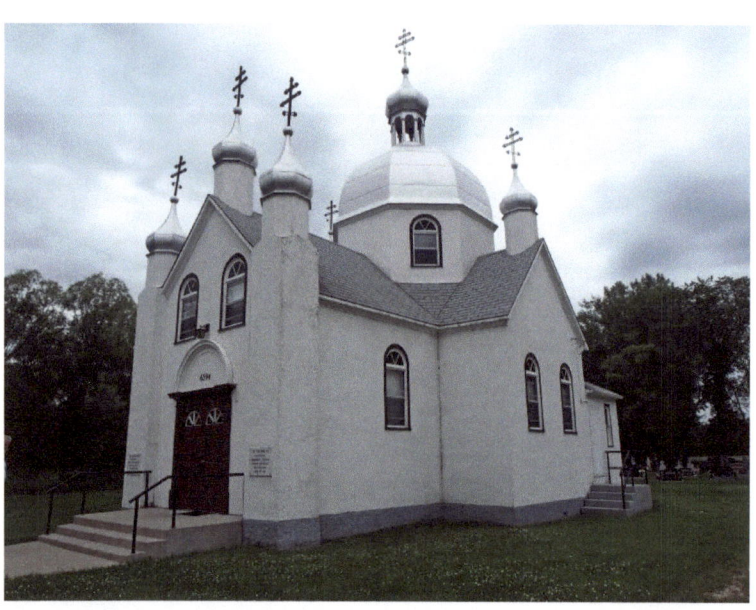

The history of the St. Nicholas Parish begins in the year 1896-1897 when immigrants from Bukowina, Ukraine settled in the Gonor district. The Gonor district was already established by a Jesuit Missionary, called Father de Gonnor, who through his efforts, assisted la Verendrye, the explorer, and some years later, the Canadian Pacific Railway in 1877.

As the Ukrainian settlers emigrated to Canada, one of the terminal depots was in East Selkirk, and from this point they travelled and walked to settle along the bank of the Red River in the Gonor district. Faith, physical strength, and hope, were their assets, and the church and religion was very important in the lives of these early pioneers. They desired a church building where they could open up their hearts to God. These early settlers made plans for the construction of the first church in 1904. The church and belfry were made of logs, which were brought in from the area.

In April 1944, both the original church building and manse were destroyed by an accidental grass fire. The original belfry containing the bell from Bukowina was saved and is still in use today.

The present church is about 1,100 square feet in area, is built of lumber and it is in the form of Byzantine architecture. Mr. Anton Prychun, a resident of Tyndall, Manitoba, was the master builder. All labor, with the exception of the head carpenter and painter, was provided free of charge. The church was painted and decorated in the following manner: The ceiling has sky-blue oil paint spangled with white stars. The dome has cherubim angels on and between clouds on a sky-blue background. The altar is painted in a similar manner. The walls are a cream color and a border is stenciled in a Ukrainian motif throughout the church. The Ikonastos consists of the picture of Jesus crucified at Golgotha, the Last Supper, and the twelve apostles and is painted and decorated in the Eastern Ukrainian Greek Orthodox style.

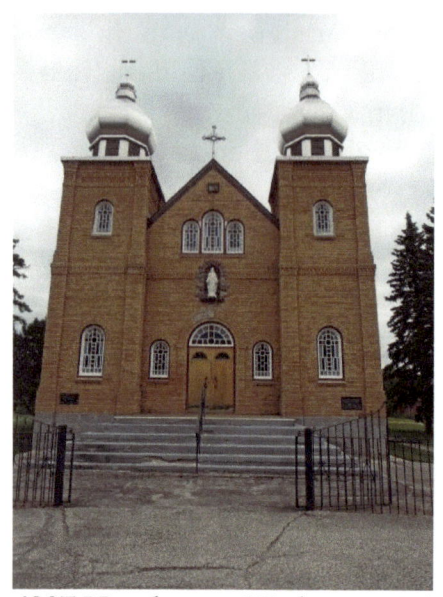 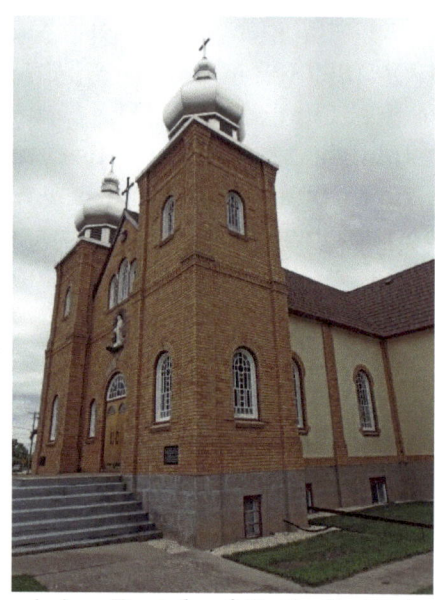

6297 Henderson Highway - Ukrainian Parish of Catholic Holy Trinity, St. Clements – 1952

Around 1890, a large influx of Ukrainian settlers was emigrating to Canada which led to the establishment of Ukrainian Catholic parishes. The first Holy Trinity Ukrainian Catholic Church was started in 1899, in the traditional Byzantine, rite style, in the form of a cross. The current church of brick and stucco structure, with its two radiant stainless steel domes, which could be seen from miles around, was built 1952-1953.

 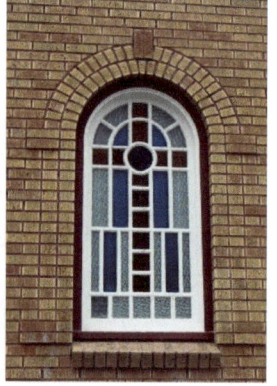

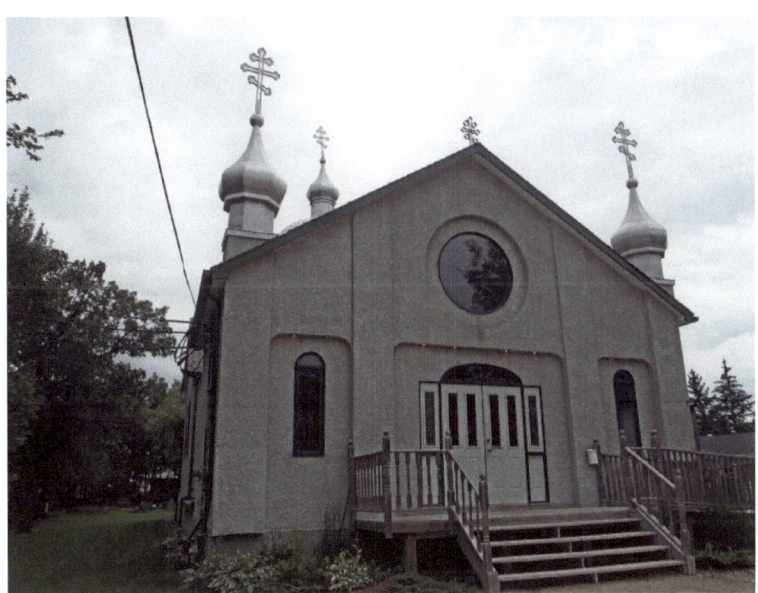

5635 Henderson Highway - St. Nicholas Orthodox Church in Narol was founded in 1911 by immigrants from the Brody area in Galicia. Like most Rusins/Western Ukrainians, these pioneers had been Greek Catholic in their homeland, which at that time belonged to the Austro-Hungarian Empire. Upon their arrival in Canada, the people reunited with the Orthodox Church of their forbearers, becoming a part of the Russian Orthodox Mission.

Architectural Terms

Bay Window: A window that projects out from a wall, in a semicircular, rectangular, or polygonal design. Used frequently in Gothic and Victorian designs. Example: Tarrow House, Page 5	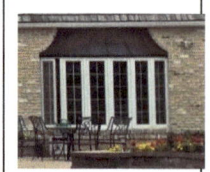
Buttress: a masonry structure built against or projecting from a wall which serves to support or reinforce the wall. In Canadian architecture, they are sometimes used for decoration. Example: Page 17	
Cobblestone architecture: Refers to the use of cobblestones embedded in mortar as a method for erecting walls on houses and commercial buildings. Example: Kennedy House, Page 12	
Dome: Any roof structure that is curved and spans an ultimately circular base. Squinches and pendentives are used to provide a circular base on a square or rectilinear tower. A squinch is a construction filling in the upper angles of a square room so as to form a base to receive an octagonal **or** spherical dome. When a square space is vaulted to provide a circular space for a dome the resulting curved triangular supports are called pendentives. This is most common in Byzantine architecture. Example: Page 26	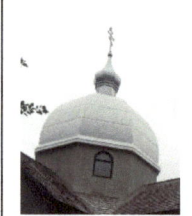

Dormer: (French for "sleep") a gable end window that pierces through the plane of a sloping roof surface to create usable space in the top floor or attic of a building by adding headroom. Example: Tarrow House, Page 5	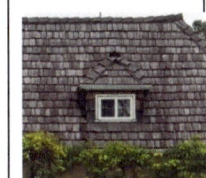
Gable: the triangular portion of a wall between the edges of a sloping roof. Example: Kennedy House, Page 12	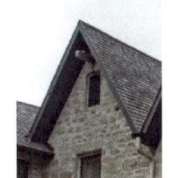
Lancet Window: a tall, narrow window with a pointed arch at its top. Example: Page 17	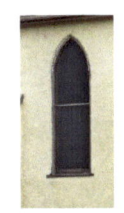
Oriel Window - These small areas were originally set into walls and galleries for the purpose of private prayer. Over time, any projecting window or area on an upper floor was called an oriel. Example: Tarrow House, Page 5	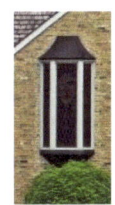

Sidelight: a vertical window that flanks a door, and is often used to emphasize the importance of a primary entrance. **Transom Window:** the light above the doorway, also called a fanlight. Example: Page 29	
Tower: A circular, square, or octagonal vertical structure higher than the surrounding structure that is usually part of an existing building and is created either for extra defense or for a specific purpose such as a clock or a bell tower. Example: St. Thomas Anglican Church, Page 18	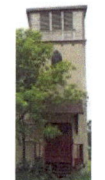

Building Styles

Byzantine architecture is that of the Byzantine Empire. Byzantine architecture was mostly influenced by Roman and Greek architecture and later Sassanian and Islamic influences to an extent. This terminology is used by modern historians to designate the medieval Roman Empire as it evolved as a distinct artistic and cultural entity centered on the new capital of Constantinople rather than the city of Rome and environs. The empire endured for more than a millennium, dramatically influencing Medieval architecture throughout Europe and the Near East, and becoming the primary progenitor of the Renaissance and Ottoman architectural traditions that followed its collapse. One of the great breakthroughs in the history of Western architecture occurred when Justinian's architects invented a complex system providing for a smooth transition from a square plan of the church to a circular dome (or domes) by means of pendentives. A distinct style gradually resulted in the Greek cross plan in church architecture. Buildings increased in geometric complexity, brick and plaster were used in addition to stone in the decoration of important public structures, mosaics replaced carved decoration, complex domes rested upon massive piers, and windows filtered light through thin sheets of alabaster to softly illuminate interiors. Most of the surviving structures are sacred in nature. Example: St. Nicholas Church, Gonor, Pg. 25	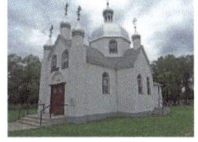

An English country house/manor is a large house or mansion usually unfortified. Example: River Road, Page 5	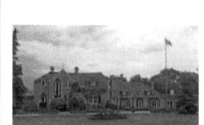
Gothic Revival, 1830-1890 – These decorative buildings have sharply-pitched gables with highly detailed verge boards, pointed-arch window openings, and dichromatic brickwork. It is a common style in Ontario. Example: 3 St. Andrews Road, Page 6	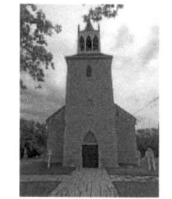

www.ingramcontent.com/pod-product-compliance
Lightning Source LLC
Chambersburg PA
CBHW041118180526
45172CB00001B/304